MW00834491

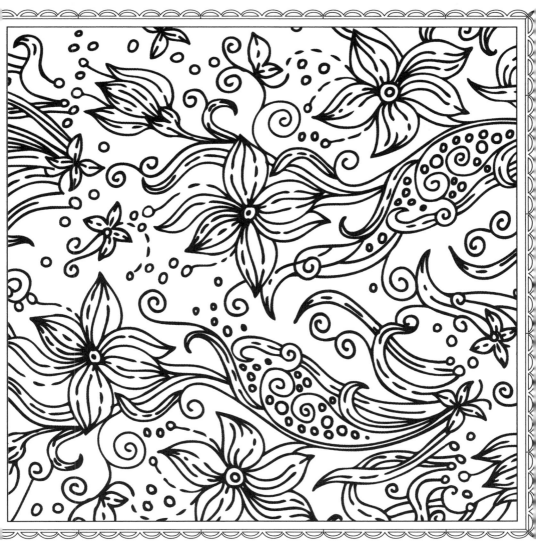

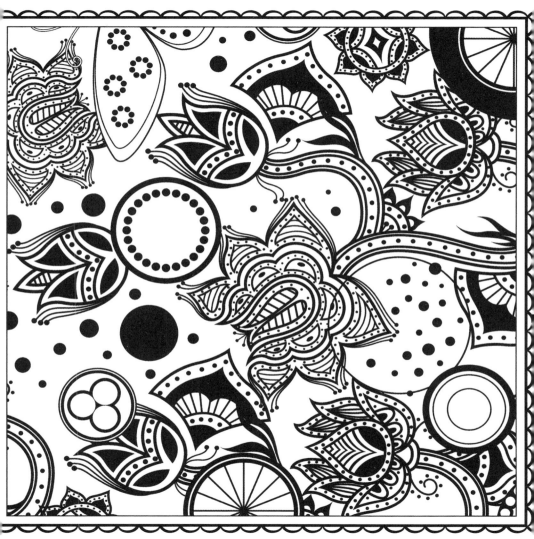

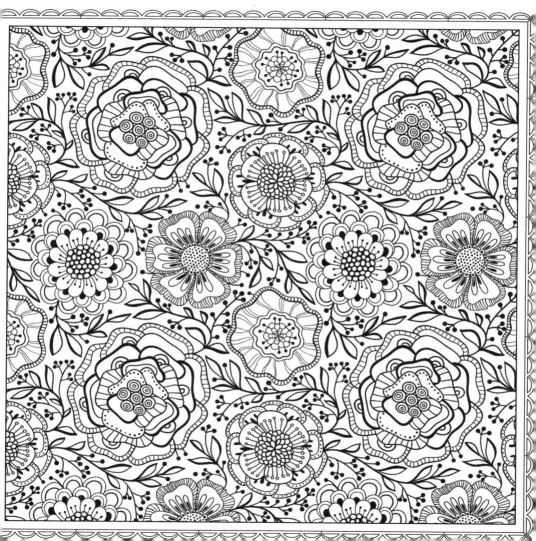

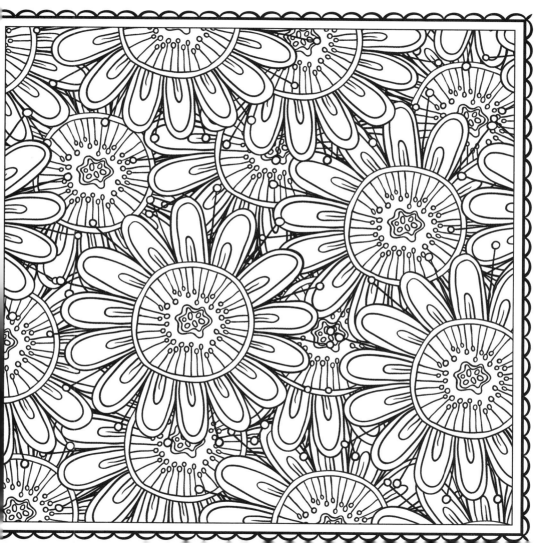

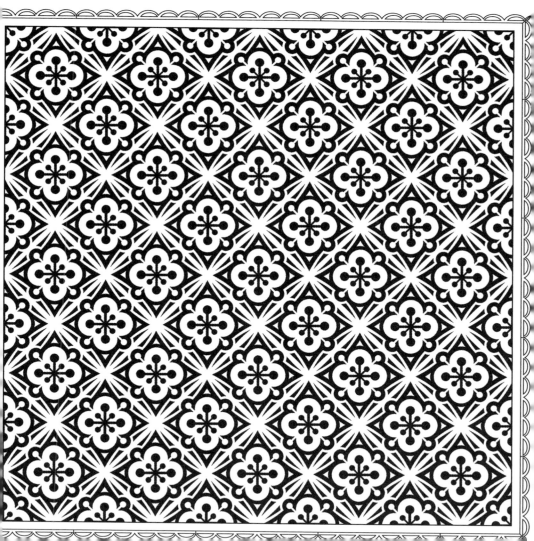

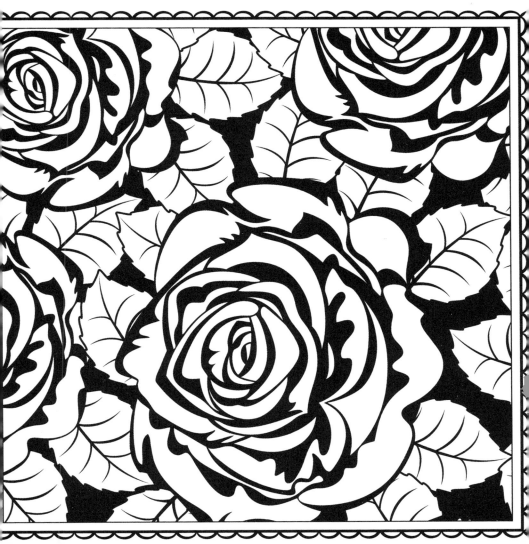

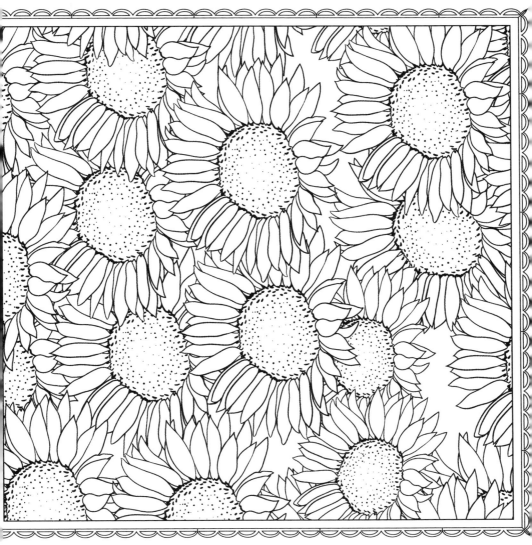

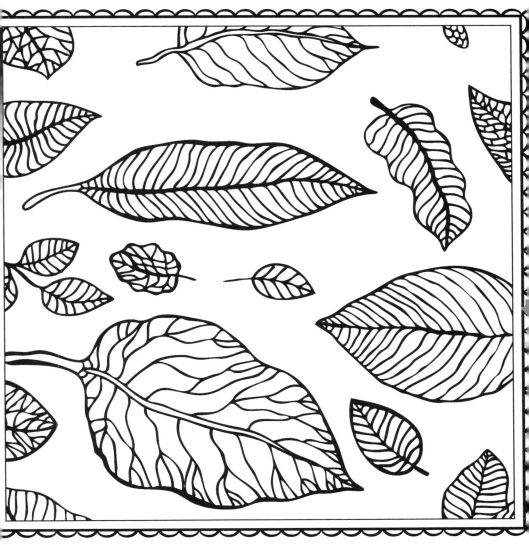

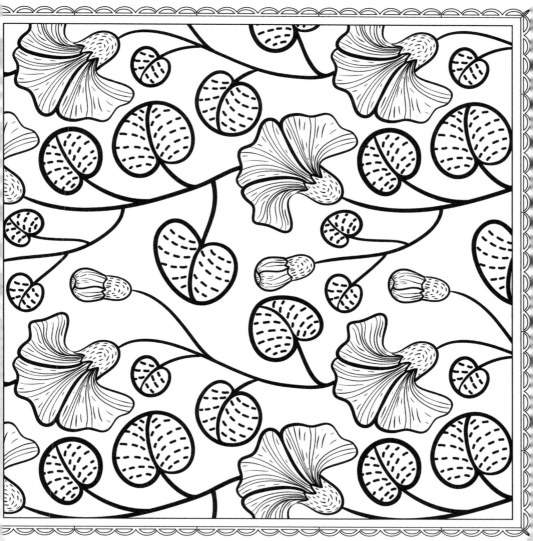

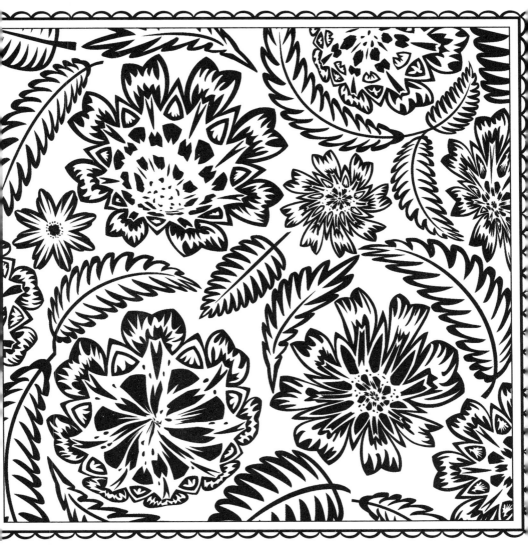

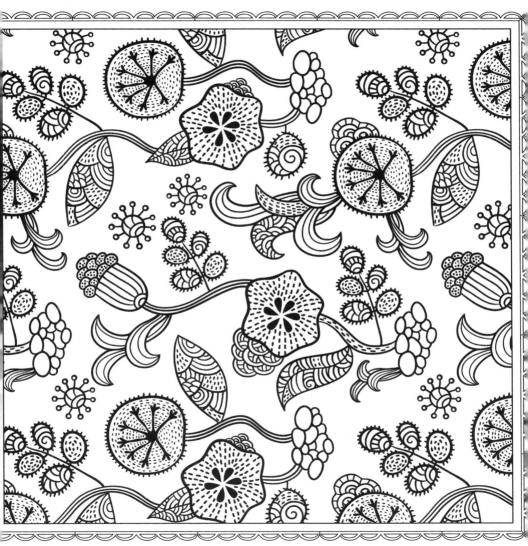

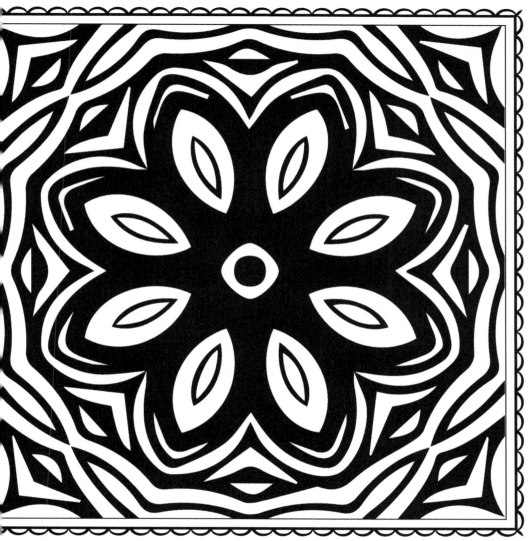

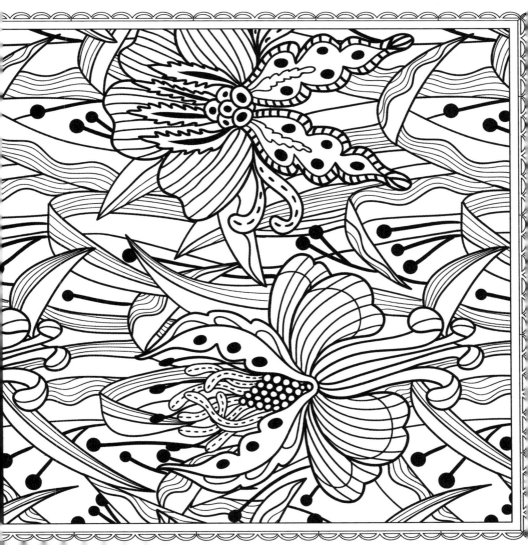

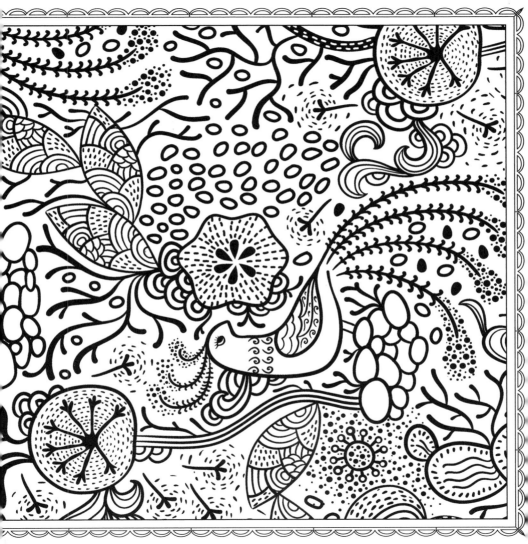

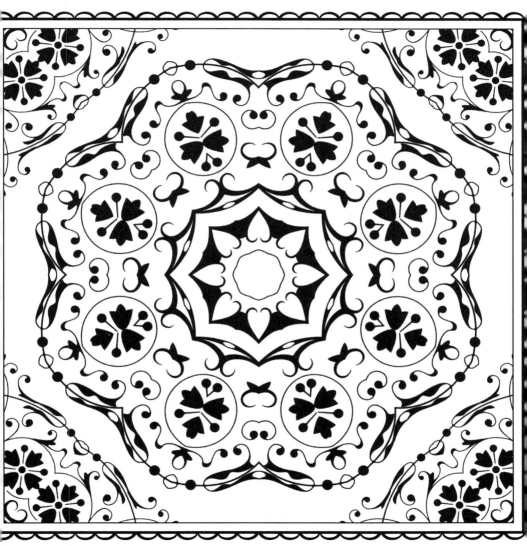

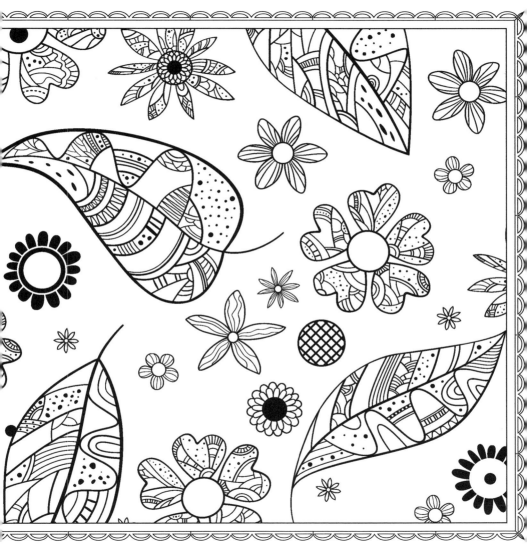

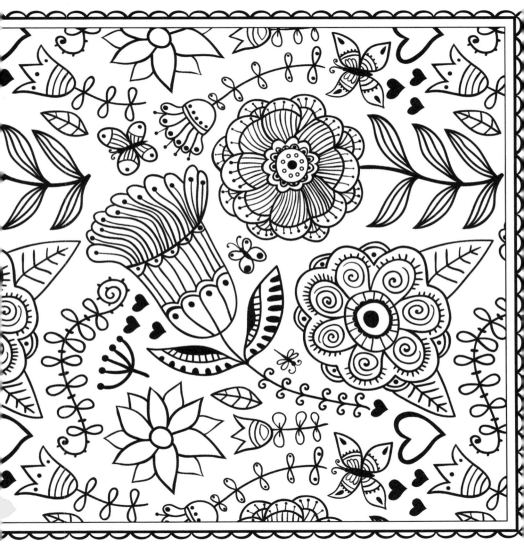

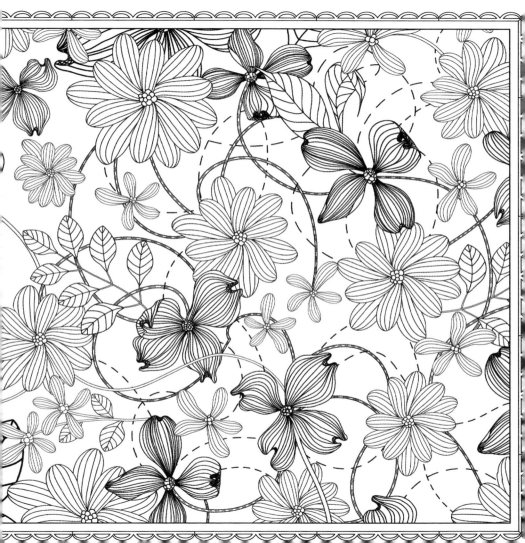

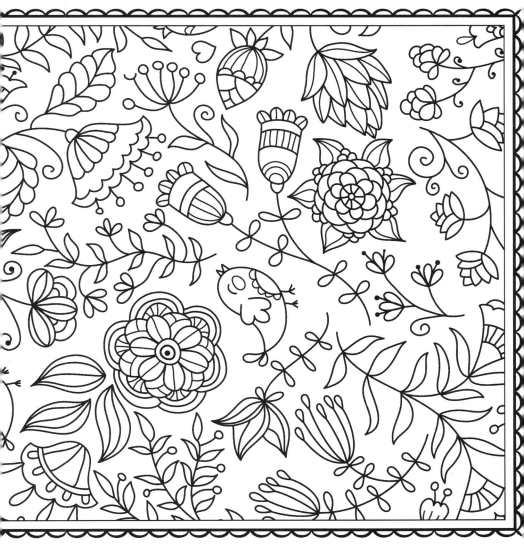

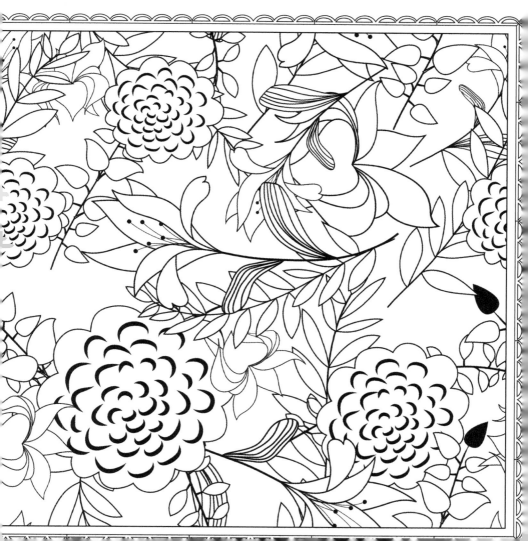

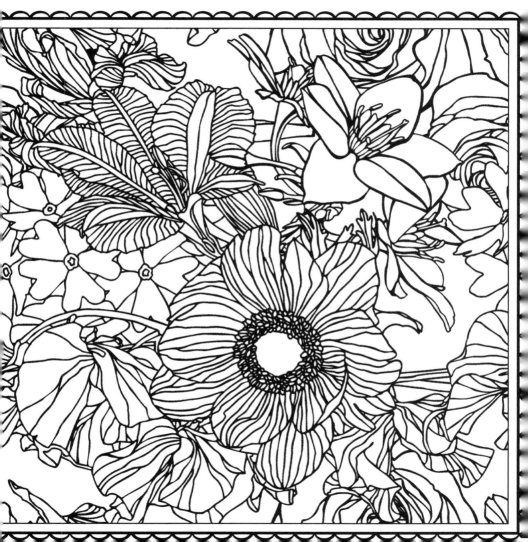

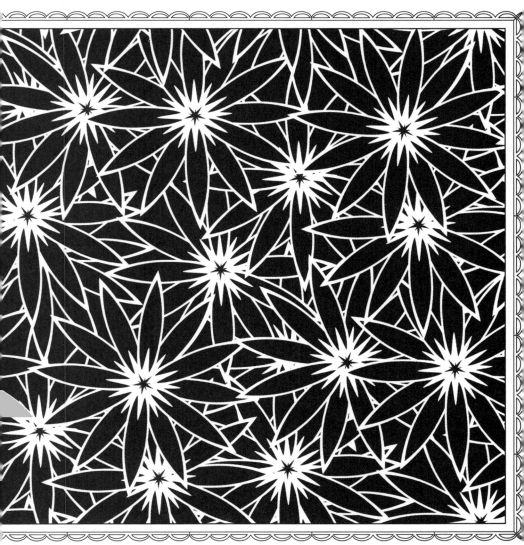

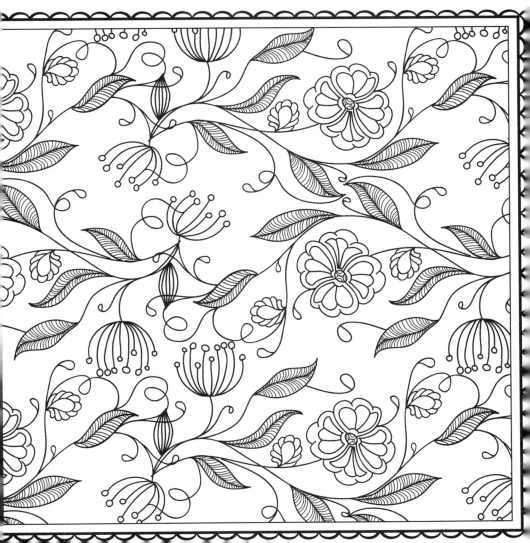

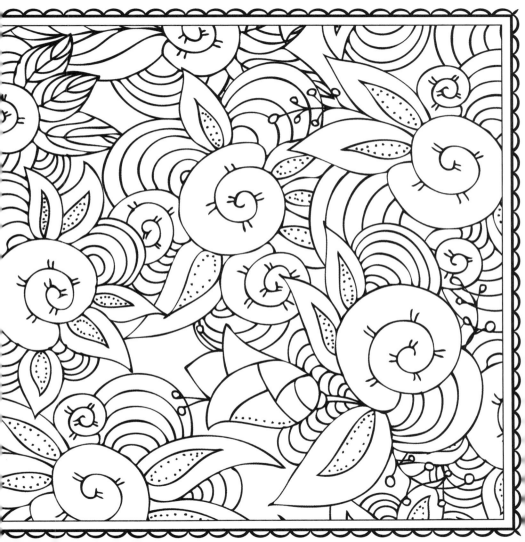

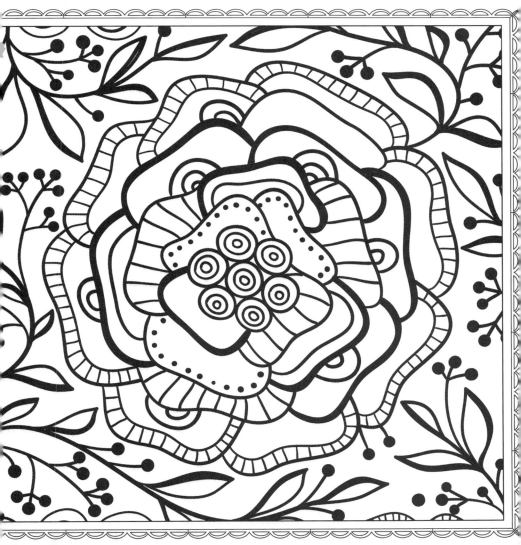

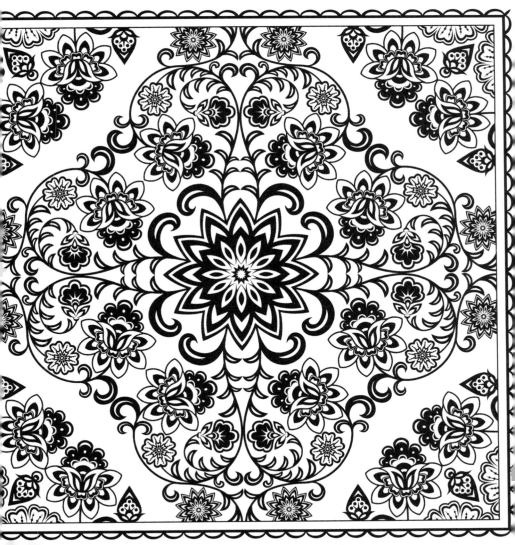

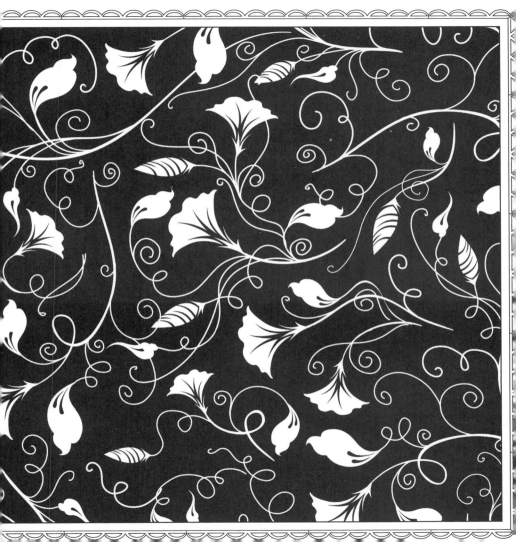

Look for these other titles in the Mini Pads of Color series by Barron's

MANDALA DELIGHTS

ISBN 978-1-4380-1010-6

SEA OF FLOWERS

ISBN 978-1-4380-1012-0

ENCHANTING MANDALAS

ISBN 978-1-4380-1011-3

First English-language edition published in 2017 by
Barron's Educational Series, Inc.
Original German title: *Blütentraum*
© Copyright 2016 arsEdition GmbH, München

All rights reserved.
No part of this book may be reproduced in any form or by any
means without the written permission of the copyright owner.

All inquiries should be addressed to:
Barron's Educational Series, Inc.
250 Wireless Boulevard
Hauppauge, New York 11788
www.barronseduc.com

ISBN: 978-1-4380-1009-0
Illustrations: Getty Images / Thinkstock
Printed in China
9 8 7 6 5 4 3 2 1